Lifelines 55

Capability Brown
An illustrated life of Lancelot Brown
1716-1783
Joan Clifford

Shire Publications Ltd.

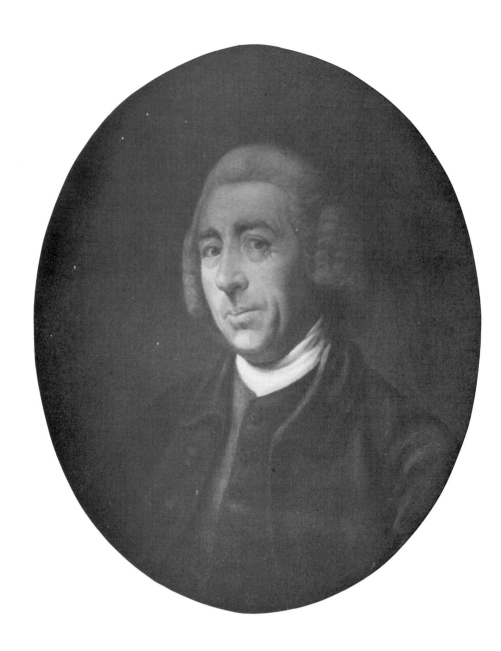

Contents

ACKNOWLEDGEMENTS
The author wishes to thank the following for their help in her researches: Miss Janet Barratt and the staff of the Central Library, Bromley, Kent; the Librarian of the Royal Horticultural Society; and Mrs Margaret Morrice of Colchester, for access to the personal account book of Capability Brown, the book owned by her and in the care of the RHS library.
Illustrations are acknowledged as follows: pages 2, 26 (right) and 35, National Portrait Gallery; page 4 (bottom), Buckinghamshire County Museum; page 9, Barber Institute of Fine Arts, University of Birmingham; pages 11, 14 (both) and 26 (left), Cadbury Lamb; page 12, Guildhall Library, City of London; page 17, The Stamford Mercury; page 18, His Grace the Duke of Marlborough (photo: Oxford Mail); page 23, Mr J. M. Fisher, Superintendent of Royal Parks and Gardens, Hampton Court (photo: Morris Walker); page 29, Mr Edward Wilson; page 31 (top and bottom), by permission of the Governors of Claremont School Trust Ltd; page 37, the Librarian, St John's College, Cambridge; page 38, F. G. Masters; page 43, Radio Times Hulton Picture Library; page 45, Yorkshire Post Newspapers.
The cover photograph by Cadbury Lamb is of the Doric temple on the lake at Bowood, Calne, Wiltshire.

Printed in Great Britain by C. I. Thomas & Sons (Haverfordwest) Ltd, Press Buildings, Merlins Bridge, Haverfordwest, Dyfed SA61 1XF.

Opposite: Lancelot Brown Esquire, a portrait by Nathaniel Dance.

Above: The parish church of **Kirkharle**, *Northumberland, birthplace of Lancelot Brown. An illustration from Hodgson's 'History of Northumberland', part II, vol. 1 (1827).*

Below: A view from the Grecian temple to Lord Cobham's pillar at Stowe, the Buckinghamshire estate of Lord Cobham where Brown became under-gardener in 1740 while the park was being developed by William Kent.

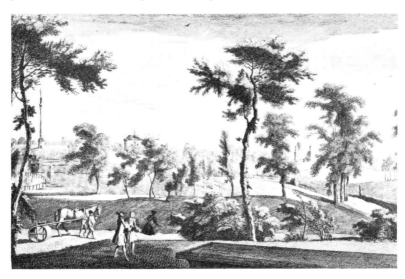

A quick rise to fame

CHILDHOOD AND YOUTH

Lancelot Brown was born in 1716 in the Northumberland hamlet of Kirkharle. He was destined to transform the crowded, geometric gardens of the day into the English park gardens, with their hills, lakes and trees. In such gardens, declared Horace Walpole, England 'discovered the point of perfection' and gave 'the true model of gardening' to the world.

Practically nothing is known of Brown's family or of his upbringing in the secluded countryside where they lived. Brown attended school in the village of Cambo, two miles from his home. His education was probably less sketchy than his detractors sometimes claimed, since he remained at school until the age of sixteen. He was then apprenticed to a local landowner, Sir William Loraine, on a modest estate and given a thorough training in basic skills which served him well in later life. He could always describe with authority to a subordinate exactly how to dig and hoe, raise young plants and replant old ones, how to drain wet land and what trees were suitable for differing sites.

Sir William did not engage much in 'improving' his property — meaning a general improvement in the appearance of the grounds and' also the economic advancement of the farms. However, Brown would have noticed trends in nearby gardens and formed his own opinions on alterations. Not far away was Wallington, overlooking the river Wansbeck. The road cutting through this estate, though sunken, was a public right of way and no attempt was made to hide the house. Apart from evidence of recently discovered plans for Rothley Lake, it is not thought that Brown himself worked at Wallington.

MOVE TO STOWE

In 1739, well-trained and ambitious, young Brown travelled south and found work at Wotton, the property of Sir Richard Grenville. This

proved a crucial move, since it brought Brown to the notice of Grenville's son-in-law, Lord Cobham, owner of the famous Stowe Park, a great estate in Buckinghamshire. A year later, Brown became under-gardener at Stowe. It was understood that a 'person who acts as gardener to noblemen or gentlemen must make himself well acquainted with cultivation of fruits, flowers, vegetables and in general everything growing in gardens either for pleasure or use'. Brown would seem to have been well qualified.

Lord Cobham had served in Marlborough's wars and was the husband of an important and wealthy heiress. He was not only politically active but keenly interested in improving his estate, where Whig leaders congregated socially and visitors came from all over the world, not least to view the renowned gardens. Famous designers such as Vanbrugh and Bridgeman had worked on the house and gardens, culminating about 1730 in the attentions of William Kent, a protégé of the Earl of Burlington, of whom Horace Walpole said that he 'leaped the fence and saw that all nature was a garden'.

Kent, who was born in Bridlington, Yorkshire, in 1684, had shown early artistic promise and was sponsored by the local gentry to study art and architecture in Rome. He met Burlington in Italy and studied with him the architectural style of Palladio. The Earl then introduced him to wealthy clients and under Burlington's aegis Kent developed a successful practice in architecture, landscape gardening and furniture design. The Burlington House set had adopted the philosophy of Platonic Idealism, promulgated by the Earl of Shaftesbury, which posited that beauty of life and beauty of form are complementary aspects of the human ideal. Kent's work was based on these theories; like the landscape painters, it was his intention to appear to restore a pristine perfection to nature. His garden designs revealed a trend towards nature, but nature artfully controlled. The practical effect was to soften hard edges by uneven planting and remove or blur straight lines. Gardens were planned as landscape paintings, using hills, water, trees, sham ruins, mossy caverns, statuary and a concentration upon perspective to achieve the so-called 'natural' results.

THE WORK OF WILLIAM KENT

The principles of Kent's work are well illustrated at Rousham House, Steeple Aston, north of Oxford. Here, on a steep bank of the river Cherwell, he worked between 1720 and 1725. Much remains

today as Kent designed it. Paths wander through groves to the seven-arched portico of Praeneste, numerous temples and statuary. Venus gazes down her Vale and one can see the typical Gothic focal point, or 'eye-catcher', designed by Kent himself. Near to the house is the attractive older walled garden with its dovecote.

Kent's building designs were called Palladian, inspired by Andrea Palladio, their main characteristics being simplicity of outline and perfection of proportion, as exemplified in Tottenham Park, Wiltshire.

At Stowe, Kent found two areas undeveloped and he created the Elysian Fields and the Grecian Valley, though his ideas permeated all the gardens. He probably 'serpentined' the previously geometric waters and initiated the use of untrimmed trees. He created a series of 'pictures'.

When Lancelot Brown came to Stowe the Elysian Fields were in their final stages and Brown could not but be influenced by Kent's designs. He was surely responsible, as promotion came, for the execution of Kent's plans. He probably considered them fussy, since Kent was at his best working on small areas, whereas Brown, as he developed, thought in terms of long belts of woodland and altogether on a larger scale.

Brown witnessed new theories in action at Stowe: he saw how the ha-ha, or sunken fence, of military origin, introduced by Kent's predecessor, Bridgeman, dispensed with enclosing walls and threw open the countryside to the gardens. The ha-ha was not visible until reached, but effectively excluded straying animals.

The gardens of Europe had grown steadily outwards, walls and moats disappearing.

GARDEN DEVELOPMENT

The Italian Renaissance architectural garden, at its peak between 1500 and 1570, had dominated Europe and gardening had become a fine art. The essentials of the Renaissance garden were not so much in its specific features as in the attitude to life of its creators, who no longer thought of a garden as an afterthought but as an integral part of a property.

England, where very little gardening as we know it took place until Tudor times, responded slowly to Italian influence, though two great gardens were built at Nonsuch and Hampton Court. These were in-

clined to be piecemeal in construction and the idea of a unified garden was not put forward until the end of the sixteenth century, in the writings of Francis Bacon. The Tudor knot gardens were intricate raised beds, comprising patterns of clipped shrubs, such as dwarf box, rosemary or thrift, filled in with coloured gravel or ornamental flowers. The knots bore such names as Tre-foy, Flower-de-Luce and Oval.

The Renaissance influence in France was noticeable in its gardens, which became elaborate and exotic, with their massed trees and clipped evergreens and ingenious use of water in lakes, canals, fountains and cascades. This interest developed and rose to a peak under the genius of André Le Nôtre (1613-1700), appointed garden designer to Louis XIV in 1640 and the great exponent of formal design. Le Nôtre, draughtsman and mathematician, as well as gardener, came from a family of gardeners and had been taught in the Tuileries gardens by Mollet. Le Nôtre, an intellectual, gloried in a sumptuous garden, arousing interest by hidden groves and tricks of perspective. At Versailles Le Nôtre created one of the most important gardens in Europe, where the vista from the west front seems to make straight for the sun in the evening.

Knot gardens gave way to embroidered parterres, best viewed from above and judged by symmetry, proportion and variety. The parterres were cut fancifully into the shapes of animals, birds or foliage. The few flowers planted within the parterres were low growing. Much attention was paid to the planting of woods. Avenues radiated stiffly from a central point into the country beyond. Sculpture was common, also ornamental canals and topiary. Nature was entirely subordinate to art.

In England after the Restoration interest quickened also, directly under French influence, and many French designers, such as the brothers Mollet, came here to work. André Mollet was famous for his goose-foot design, a half-circle with five diverging avenues, of which Hampton Court is a good example.

Dutch influence, following the accession of William of Orange, increased the use of topiary in English gardens. This could be beautiful, as in the gardens still extant at Levens Hall, Westmorland, but often reached absurd degrees in the 'cones, globes and pyramids' which Addison scorned. For such gardens London and Wise produced clipped greens in vast quantities.

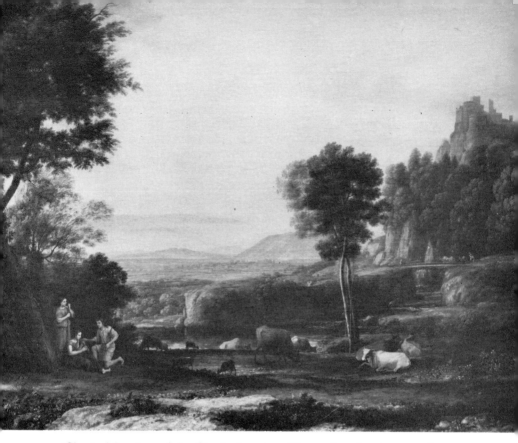

'Classical Landscape' by Claude Lorraine. The works of painters such as Claude Lorraine, Salvator Rosa and Poussin influenced the trend towards 'natural' garden design.

TIME FOR CHANGE

Cultivated people now discussed the need for change, a wish to move away from existing stiffness and formality to a style more akin to 'nature'. Writers, philosophers and painters were in the forefront of such discussions. The poet Pope, a gardening enthusiast, satirised the extremes of topiary and Addison of the *Spectator* enthused about 'natural beauty' and 'spontaneous form'. The word 'picturesque' was used to describe gardens created in the style of the painters Claude Lorraine and Poussin. Paintings such as Lorraine's 'Classical Landscape' and Rosa's 'Baptism in Jordan' illustrate this clearly, with their wide landscapes with ruins and temples. Philosophers talked about 'natural innocence' and sought its representation in landscapes.

Perhaps the basic reason for the gardening revolution in England

was simply the addiction of the nationals to country walks and the desire to adapt the gardens to this requirement, the weather then as now preventing great social use of the grounds.

In spite of agreement on the need for change, alterations came only gradually. Stephen Switzer, royal kitchen-gardener at St James's Palace and author of gardening books for the nobility, suggested that paths should have 'as many twinings and windings as the villa will allow', but, until Kent's influence, progress was unremarkable.

At Stowe, given Kent's impetus, new theories were becoming effective. Lancelot Brown rose in the gardening hierarchy with astonishing speed. He was promoted to the pleasure gardens and ultimately to the post of head gardener. Basic skills, increasing authority and ambition spurred him on, as well as very definite ideas of his own. Famous visitors came to Stowe and Brown often accompanied them on tours of the grounds. In informal conversation he impressed others with his opinions, regardless of their rank.

LANCELOT'S OPPORTUNITY

Eventually, perhaps through Kent or the influence of Lord Cobham himself, Brown was offered a commission to 'improve' the estate of a neighbouring landowner, the Duke of Grafton. Lord Cobham encouraged Brown to proceed and Lancelot embarked upon a scheme for the Wakefield estate which ultimately displayed the elements of design for which he was to grow famous. This consisted basically of a park bounded by an encircling belt of woodland, an inner belt softened by clumps of trees and the bold use of water. In striving after 'natural' effects he sought to achieve what Hogarth called the 'line of beauty', a wavy effect produced by serpentine edges to the shores of lakes and rivers, skirts of woods and edges of lawns.

More clients, friends of Cobham and Kent, asked for Brown's services and were satisfied with the results. He advised on the layout of the grounds of Warwick Castle, where the restricted site presented technical difficulties. He worked steadily at Stowe but there is debate as to how much redesigning there is his own work. The official guidebook to Stowe suggests that as head gardener he must have been responsible for the execution of Kent's designs and that it is 'hardly credible' that he did not himself contribute to them. He prepared clear plans and drawings on large vellum sheets with an increasingly practised eye.

On 22nd November 1744 Brown married a local girl named Bridget Wayet in St Mary's Church at Stowe, which still stands and which Bridgeman had carefully hidden by trees. Recently Simon Whistler, the etcher, etched a record of Brown's wedding on one of the church windows.

During their stay at Stowe the Browns had four children: Bridget, born two years after their marriage, Lancelot Junior, born in 1748, William who lived only a few months, and John, born in April 1750.

A PRACTICE OF HIS OWN

William Kent died in 1748. He had worked intermittently at Stowe over the years, towards the end of his life supervising the erection of garden buildings. Lord Cobham died the following year. Brown had worked at Stowe for nine years, privately designing as proved expedient. He now felt equipped to engage in full-time practice. It had

St Mary's church, Stowe, Buckinghamshire, where Lancelot Brown married Bridget Wayet on 22nd November 1744.

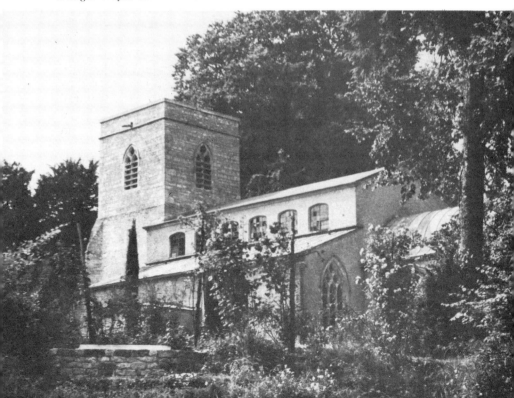

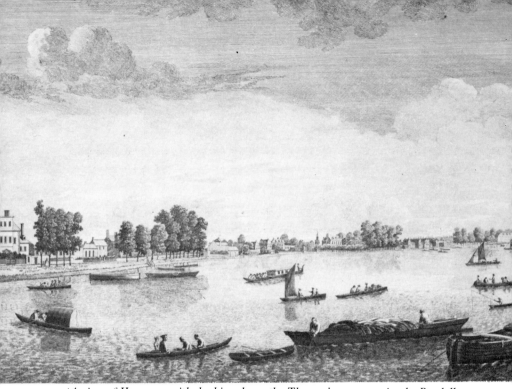

'A view of Hammersmith, looking down the Thames', an engraving by Boydell (1752), showing the village at about the time Brown moved there to live and work.

already become fashionable to employ Brown, despite the muted commendation of Horace Walpole who, in 1751, speaking of the Warwick Castle gardens, observed that they were 'well laid out by one Brown who has set up on a few ideas of Kent . . .'

With his wife and young family Brown moved about 1750 or 1751 to the pleasant hamlet of Hammersmith, adjoining the village of Fulham on the outskirts of London. Here he could meet important landowners, who often visited the capital. He was also near to the market gardens for which the area was renowned. There were many nurseries on the stretch of land between Brompton and Fulham. There were also in London small-scale nurseries in Hoxton, Lambeth, Whitechapel and Hackney. One of the most extensive in London during the first half of the eighteenth century was that belonging to Robert Furber of Kensington. Another famous nurseryman was James Lee of the Vineyard, Hammersmith, whose gardens were situated where Olympia now stands. Lee's firm issued an important catalogue of plants and introduced foreign specimens. Loddiges at Hackney was also important

and noted for the introduction of American plants. Nurserymen were raising new specimens from all parts of the world and the descendants of James Gordon, who set up at Mile End in 1645, owned a flourishing seed shop in Fenchurch Street. Very little is recorded of nurserymen outside the London area. Much material also was obtained from the gardens of the large estates, where propagation was a commercial undertaking.

Henry Wise, royal gardener to Queen Anne, with his partner George London had founded the famed Brompton Park hundred-acre nurseries in 1681 and had drawn upon these both for his own contracts and to retail to other designers throughout the country. Unlike Wise, Lancelot Brown set up no nurseries of his own but ordered and purchased from local sources or overseas, as most attracted him.

The Browns soon made a significant friendship with the Holland family who lived at Fulham. Henry Holland was a successful master builder and architect. His wife and children were soon on close terms with Bridget Brown and her young family, while Henry Holland and Lancelot Brown found much in common, their acquaintance soon developing also into a fruitful business association.

It was probably Holland who helped Brown to absorb the principles of architecture when he decided to extend his activities to include houses as well as gardens. Brown's reasons were not only economic, but also artistic in his desire for unity of design within a property. Though never brilliantly original as a house-designer, Brown found his efforts acceptable and extended his business in this direction. He negotiated with Henry Holland for building work which Holland would subcontract to various carpenters, plasterers and plumbers.

CROOME

His initial commission in his new practice was at Croome, Worcestershire, for Lord Coventry in 1751. It was daunting, since he acted as land engineer, architect and garden designer. It necessitated a major drainage scheme for the park, using deep culverts, because of the poor site, a marshy piece of ground formed by the junction of the rivers Avon and Severn. Massive labour forces were needed. The house had first to be pulled down and Brown demonstrated a bold attitude to what he regarded as necessary demolition that sometimes incurred criticism. The poet Pope observed that 'improvement, the idol of the age', was 'fed with many a victim'. However, Brown's faith in his own

13

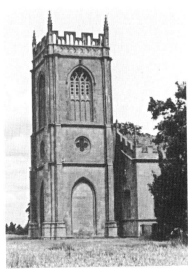

Croome Court, Worcestershire, was the seat of Lord Coventry and Brown's first architectural commission. He also built the look-out or panorama (left) and rebuilt the church of St James, Croome d'Abitot (right) in 1763.

ideas was vindicated. He erected at Croome a dignified Palladian house and though much interior decoration was wrought by the celebrated Robert Adam, Brown himself designed the hall with its fluted columns and the white and gold salon. The grand lodge was an important feature as was the ice house, in use until 1915. Brown also rebuilt, in Gothic style, the church of St James the Apostle.

Croome was painted by Richard Wilson, a pioneer in English landscape painting. Wilson was influenced by Claude Lorraine and Poussin but developed his personal style, uniquely portraying nature without adding classical buildings or other accessories and achieving gentle serenity. It is interesting to note that British landscape painting as a serious art form developed concurrently with the formation of the landscape garden and formidable practitioners included Gainsborough, Paul Sandby, Thomas Girtin, John Croome and, in due time, Turner.

ACQUIRING A NICKNAME

Brown's reputation grew. He was given the nickname of 'Capability' because of the quick, imaginative and practical assessment he made of

14

the 'capabilities' of a property's improvement. Clients found that a rapid ride round their estate, some calculations and a little deliberation soon produced a suitable scheme. They learned that they could rely on this designer not to charge exorbitant fees and to be scrupulously honest. He certainly planned on a grandiose scale but usually at the requirement of the client. Where nature failed, Brown acted. If there were insufficient contours, he moved earth to make them; where no water existed, it was introduced; where no trees grew, new plantations would be placed.

Water manipulation played a vital part in Brown's plans and he delighted to form a great, tranquil lake and to convert small brooks into wide rivers. People identified his landscape and enthused over the sweeping turf, contours sloping to glimpses of broad winding river and rising to merge into the skyline of surrounding woods.

Although Brown's trees, when still standing, are now well past their prime, it is not hard to imagine what is owed to him, considering the vast scale on which he planted, always with a view to posterity. Christopher Hussey has called him the 'Director General' of our ancestral tree-planters, following in the footsteps of John Evelyn, whose *Discourse of Forest Trees* was published in 1664 and who is thought of as the father of the movement to plant ornamental trees and woodlands. Brown's favourite trees were elm, oak, beech, ash and lime, intermixed with Scotch firs and pines and a few cedars strategically placed. He had no particular tree purveyors and bought from commercial raisers, unless his wealthy clients possessed their own nurseries. For example, trees were sold in Ashridge by a Mr Scott, in Twickenham by a Mr Ash and in Hammersmith by Messrs Kennedy and Lee. It was not Brown's habit to plant mixed stands.

When hedgerows were levelled, at the beginning of reconstruction work, certain selected timber was retained to provide the new landscape with a number of mature trees. Little replanting of mature trees was carried out at that time. The new trees, many in clumps, had to remain fenced against cattle for some years before being opened out, which necessarily gave a stiff appearance. This was also true of the surrounding belts of new trees, called the 'circuit', which also looked hard until sufficiently grown for the fence to be set back.

A GROWING CLIENTELE
Brown worked industriously for his growing clientele during the

decade of the 1750s. He was offered at least nineteen important architectural commissions. His landscaping developed and his practice grew. He worked, for instance, on Kirtlington Park for Sir James Dashwood, planting a fir belt and Scotch pines; he was an originator of conifer planting on English estates. He also had a ha-ha dug at Kirtlington, to open up the view. He reshaped the gardens at Belhus, in Essex, though interrupted by illness, probably the asthma from which he continually suffered. He swept away the formal gardens at Ragley for Lord Hertford, who had been impressed by the alterations at Croome. Brown landscaped Moor Park, in Hertfordshire, already a famous garden, for Admiral Lord Anson, a large commission financed by prize money from the capture of the Spanish fleet. This involved considerable earth-moving to improve the setting of the house and the creation of a small lake. Brown worked on several commissions at one time, riding endlessly from place to place.

MAJOR TASKS

In 1756 he began, as he wrote, 'twenty-five years of pleasure' at Burghley House, Northamptonshire, the magnificent seat of the Cecils, for the Earl of Exeter. This was a vast operation. Burghley had been built in the second half of the sixteenth century for the then Lord High Treasurer and Brown was required to make alterations leaving the Gothic areas of the house unchanged. He built an imposing lodge, a bath house or banqueting hall as it is sometimes called, conservatory and orangery. In the huge park, seven miles in circumference, he put down an enormous sweep of lawn and planted chestnut, beech and fir on an immense scale. Four acres of kitchen garden were discreetly hidden. He combined the meandering streams into a lake of thirty-two acres and designed a fine stone bridge. He was very proud of his work at Burghley and his client was well satisfied.

The following year, 1757, he commenced another major scheme, at Longleat, near Warminster in Wiltshire, for Lord Weymouth, which took about four years to complete. Longleat was a Tudor semi-palace, built originally in Italian Renaissance style. Here again much labour was required for engineering — for draining and altering the lake, for earth-moving, road-building and the construction of sunken fences. Brown had decided, with the approval of his client, to remove the

Opposite: Burghley House and park, seat of the Cecil family, on which Brown was engaged for 'twenty-five years of pleasure'.

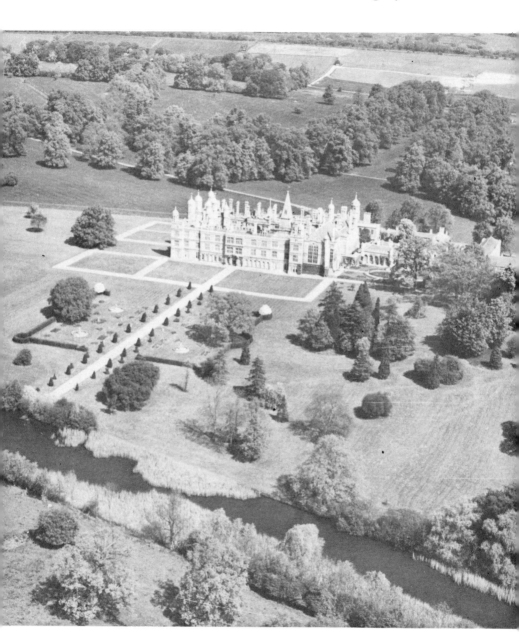

existing formal garden and replace by a park landscape. Within a year he had produced a Pleasure Walk of shrubberies, exotic trees and turf. He did not obliterate the terraces but replanted them. Many new trees were put in, including the pinus strobus, or white pine, which Lord Weymouth brought from North America and which was afterwards called by his name. The famous Mrs Delaney, on visiting Longleat, was much impressed by the fine lawn, serpentine river, wooded hills and other items of the parkland scene. Today, from the Warminster road, the 'picture' aspect of Brown's conception and execution can still be appreciated.

Brown was now past forty. He was not mock-modest and considered himself eligible for a royal appointment. Accordingly he applied for the post of royal gardener, vacant for some years. He sent his petition, signed by his friends and clients among the Whig nobility, to the patronage secretary, the Duke of Newcastle, First Lord of the Treasury. A notorious machinator, Newcastle made no response at all for a long time. He certainly regarded Brown's sponsors as his own political enemies. He vacillated and nothing came of the application. Brown had to wait another seven years before receiving royal recognition in official form.

Blenheim, Oxfordshire. Vanbrugh's bridge over the river Glyme was given a worthy setting by Brown who dammed the river to form two lakes joined by a neck of water at the bridge.

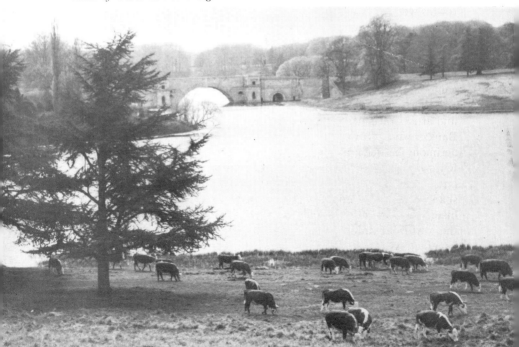

High success

BLENHEIM PALACE

Capability's penchant for large concepts was well illustrated when, early in the 1760s, he began operations on his most famous masterpiece, the Blenheim Palace garden, in Oxfordshire. This is reckoned his grandest, if not his finest, work. The huge changes made by him within the grounds were said to have cost about £30,000 in figures of the day.

Blenheim had been built largely between 1705 and 1712, at the instigation of Queen Anne, as a token of appreciation of the services to the nation of John Churchill, first Duke of Marlborough. The Queen's gift of Woodstock Park, well over two thousand acres, had been surveyed by the Duke with his architect, Sir John Vanbrugh, and a site chosen for the proposed mansion. Vanbrugh (1664-1726) was talented as a dramatist and also as an architect and park designer and famous for his work at Greenwich Hospital and Castle Howard. He designed in the florid baroque style; his work was typified by imaginative siting, the use of bastions, walls and the ha-ha, and grandeur of scale. Blenheim was a dramatic concept, the palace set high on a hill and a noble approach sweeping down to water meadows. The palace was conceived and executed on a gigantic scale — seven acres of buildings and courts — by Vanbrugh in collaboration with Nicholas Hawksmoor and artist-craftsmen such as Grinling Gibbons, the carver, and Henry Banks, who rib-vaulted the vast kitchen. Soaring costs caused acrimony between Vanbrugh and Duchess Sarah. One item of contention concerned Vanbrugh's 'ridiculous bridge', as Sarah called it, an edifice comprising thirty-three rooms which most unsuitably spanned the little river Glyme. Many financial vicissitudes beset the history of Blenheim over the following decade, occasioned largely by the disfavour into which the Churchills fell with their former benefactress.

The first Duke had shown a strong personal interest in his great formal stone-walled garden, about seventy-seven acres, laid out by Henry Wise, royal gardener, shrubs and plants being delivered from the Kensington nurseries of London and Wise. Wise had hard basic work to accomplish; he had begun by digging the palace foundations, through stiff clay to rock; he had successfully transplanted full-grown elms for the two main avenues, it having been hinted that time was of the essence regarding the Duke's health. The main gardens were twofold: the kitchen garden, half a mile from the palace, and the Great Parterre, spread out for the full width of the south front of the palace. The Parterre's containing wall had eight bastions, each 150 yards wide, and a raised walk from which to look down on the box-wood patterns woven among marble chips and the intricate evergreen labyrinths. Fountains in 'basons' played round the house and lime-espalier walks were carpeted with sand. Work on these plans went on for three years.

The plans were completed by Charles Bridgeman, another royal gardener. By the accession of the fourth Duke, in 1758, fashions had altered and he called in Lancelot Brown to 'make improvements'. To create a landscape picture, Brown boldly swept away all the gardens except the eight-acre kitchen garden, with its fourteen-foot brick walls.

He altered the formal topography and planted irregular tree stands. He designed a Gothic lodge and granary and cart house. Most triumphantly, he dealt with the awkward Grand Bridge, ensuring for it the worthy setting it required and putting it in scale. The ground-floor rooms of the bridge were flooded, submerging the base of the bridge, and the pumping engine was removed from the northern arch. The river Glyme was dammed, forming two huge lakes, joined by a neck of water at the Grand Bridge. Delightful cascades drained the new lakes into the old river course and there were further cascades where the Glyme joined the river Evenlode, which itself then joined the Thames. Brown is said to have remarked jokingly 'the Thames will never forgive me', but generations have admired his landscaping and the official guide-book to the Palace describes the lake as 'the most magnificent private lake in the country'.

Brown's activities at Blenheim brought him greater fame, which spread abroad, even so far as America. Although he had been disappointed not to receive an immediate royal appointment, he was

too busy to brood; commissions were rolling in. The general style of his designs was well established, that of 'natural' landscaping, obliterating aspects of the old geometric art. Flower, fruit and kitchen gardens were discreetly tidied away behind walls. Each property offered a unique challenge. Brown seized all chances and travelled tirelessly over the country's bad roads, rapidly assessing 'capabilities', making designs and having them executed. He employed a system of sub-contractors, supervising the different stages of operations and checking costs carefully. Sometimes he simply prepared plans and charged for these, leaving the execution to his clients to arrange elsewhere. Disbursements made to his employees, shown in his personal account book, are often for 'journeys and plans' and for 'measurements' and such items as, at Ashridge in 1768, 'to Mr Scott for trees'.

A PASSION FOR IMPROVEMENT

Brown was intermittently troubled by asthma but these spells did not prevent him from adhering to a rigorous timetable. The spending power of the three hundred leading families in Britain was enormous and the great landlords could draw six-figure incomes from their rent-rolls. Consequently the passion for 'improvement' swept on. Within the fine houses elegant Georgian furniture appeared, statuary brought home from the grand European tours and, as the century wore on, English porcelain.

In 1761 at Corsham Court, Wiltshire, Brown began work on both the house and the garden. Here he was required to enlarge the existing Jacobean house to accommodate the imposing picture collection of the owner, Paul Methuen. This he achieved by doubling the existing wings of the house, in style copying the original as directed, and managing this with skill. He prepared fifteen drawings, plans and elevations for Mr Methuen and his estimate for work to the value of £1,020 included much draining and levelling of ground, making 'great Walks', a ha-ha along two boundaries and a lake, as well as considerable planting.

The new part of the west wing housed the library and the new east wing the splendid long picture gallery, as well as other rooms. Brown supervised the interior decoration and successfully submitted a design for an elaborate plasterwork ceiling for the gallery, which was accepted and executed by Thomas Stocking, a well-known Bristol plasterer.

Brown was willing and able to attempt all aspects of design, con-

ceiving of all art as one unity. During his work at Corsham, he was unwell, probably suffering again from his enemy, asthma, and wrote — 'I cough night and day'. But his indisposition was temporary.

CONQUERING ALNWICK

The grounds of Alnwick Castle, Northumberland, presented the challenge of immense size; the property was enormous. Fortunately the owner, the Duke of Northumberland, an ardent improver with whom Brown grew increasingly friendly, was in a position to spend liberally. Good finances were essential at Alnwick, to transform the rough, treeless grassland in which the castle was isolated, over which the east winds blew from the nearby sea, and whose general aspect was austere.

While Paine and Adam worked within the castle, Brown gradually refined the bleak scene, wrestling through his workers with the levelling and banking, so that the house stood on a terrace, and regrassing areas with fine turf and planting trees and shrubs. The turbulent river was tamed into a placidly flowing water and beyond it more regrassing and planting took place. Within three or four years, these plantations were flourishing, as evidenced by appreciative comments from a Yorkshire landowner, Walter Stanhope.

Brown made 'rides' at Alnwick, some of them ten miles long. He also discovered in the castle grounds the remains of the first European Carmelite convent which, at the Duke's request, he converted into a small zoo, a bizarre commission for Brown, who was conservative in his garden building, tending to the classical.

VARIED COMMISSIONS

Varying his commissions, Brown reclad in Georgian Gothic the vast red Tudor Tong Castle, in Shropshire, and worked in his customary way on the grounds, widening the tributary of the river Worfe and creating a fashionable cascade. At Audley End he induced great lawns to sweep down to the river Cam. At Melton Constable he repeated a favourite device, islanding the house in a sea of lawns and framing it with groups of trees. At Broadlands, Romsey, in Hampshire, he gave an Italianate look to the house for the young Lord Palmerston, whose taste was for the new and different. Henry Holland was the building contractor and the famous Angelica Kauffman painted ovals for the elaborate ceilings. In the grounds, which he landscaped, where lawns

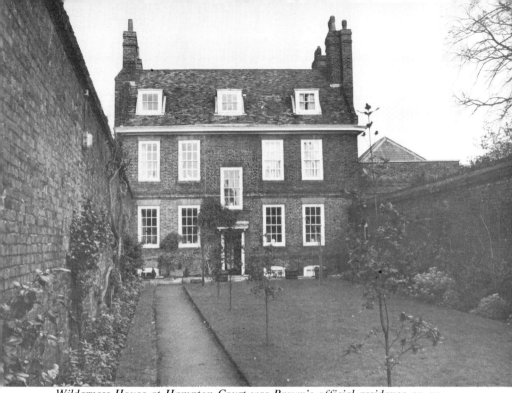

Wilderness House at Hampton Court was Brown's official residence on appointment in 1764 as H.M. Surveyor of Gardens and Waters.

went down to the river Test, Brown built a 'pretty orangery'. The work at Broadlands lasted for ten years and, according to Capability's account book, brought him over £20,000 in fees. A clear example of his signature as having received payment interestingly shows the final 'n' of his surname developed into a long horizontal flourish written underneath his Christian and surnames.

There were those critics who accused him of wholesale tree-felling but they were surely silenced when, at Fisherwick in Staffordshire, beginning in 1766, he planted no less than 100,000 trees, mostly oak, interplanted with conifers. In due time the owner of Fisherwick, Lord Donegal, was awarded a medal for his plantations. Working on this property Brown replaced an Elizabethan mansion with a Palladian house of vast proportions. Yet rather surprisingly, within fifty years the entire property had disappeared, the house being demolished and the land returned to arable.

The gardens at Luton Hoo, in Bedfordshire, produced another success. While the celebrated Robert Adam rebuilt the house, Brown commenced another ten years of landscaping at an estimated cost of

£10,000. That strange political incident, remembered as 'Wilkes and liberty', had culminated in the resignation of Brown's client, the Tory Marquis of Bute, a king's man, from the post of First Lord of the Treasury. Anti-Scottish feeling, whipped up by John Wilkes and other radicals, seized on Bute as scapegoat for the king's alleged misdoings and Bute was forced to retire. He was thus enabled to spend time, knowledge and his immense wealth upon his estates. Brown imprinted his personal style on the magnificent site at Luton Hoo. He built a lake, in which he set a number of islands, and improved the 'prospect' by beech plantations. The accounts for Luton Park are the first to be recorded in Capability's account book, a long, slim book with clear, bold figures and a fine script on the yellowing pages.

WORK IN A NEW COUNTY

At Holkham, in Norfolk, Brown was introduced to a part of the country hitherto unfamiliar to him and which had borne a reputation for bleakness and poverty. An apocryphal story declared that visitors to the county saw 'one blade of grass and two rabbits fighting for it'. However, a progression of enlightened landlords, such as the famous 'Turnip' Townshend, with his practice of crop rotation, gradually transformed the dismal, treeless waste into a productive and fertile agricultural land. One hears of Brown making a 'vast sea' of lawns at Holkham and planting an evergreen screen to hide the kitchen gardens. The estate was important to him since it led to other commissions in the area of Norfolk and East Anglia generally; a new region had opened up to him.

Occasionally, personality problems beset his dealings, as at Tottenham Park, Lord Bruce's estate on the fringes of Savernake Forest, where he was engaged in alterations. A tense situation led to Lord Bruce's agent being angered at Brown's autocratic manner and Lord Bruce grew annoyed at a failure to fix precise fees. However, an exchange of letters, with Brown in mollifying mood, saw a resolution of the crisis and confidence in the relationship restored.

Brown himself sometimes became indignant with clients. He was, for example, irritated with a Mr Dickens, owner of Branches in Suffolk. A note among his papers stated that: 'Mr Brown could not get the money for the extra work and tore the account before Mr Dickens's face and said his say upon that business to him.'

24

ROYAL APPOINTMENT

In 1760 George III came to the throne, a young man of twenty-two with simple personal tastes and a love of gardens, albeit a king determined to restore the authority of the crown. He was sociable and approachable. The ensuing changed atmosphere eased matters for Lancelot Brown in the affair of the royal patronage he had been seeking. In 1764 Brown was appointed Surveyor to His Majesty's Gardens and Waters at Hampton Court, at a salary of £2,000 a year which, according to Brown's account book, was paid quarterly with unfailing regularity. With the appointment went a pleasant dwelling, Wilderness House, near the Lion Gate at Hampton Court, in its own neat, small garden. Soon after his appointment Brown moved his family into Wilderness House and, throughout the remainder of his life, resided there for periods of time. Brown formed an easy relationship with the new king and soon won the royal ear, not only on matters horticultural. One could say the two men became friends.

Brown's new position naturally gave him authority to make changes at Hampton Court but apparently he was reluctant to do so. One anecdote indicates that the king himself mooted the replacement of the formal gardens with landscaping in Brown's style, but Capability treated the idea with reserve, 'out of respect to himself and the profession'. It is generally thought, however, that he did plant in 1768, in the corner of the old Pond Garden, the famous Great Vine, of the Black Hamburg variety, which was taken from a cutting from Valentines in Essex. Though the parent vine no longer exists, the Hampton Court vine is now seventy-eight inches in girth. It is still fruitful and the grapes are sold about the end of August.

It is probable too that Brown replaced most of the terrace steps in the privy gardens by gravel and grass slopes, though two flights were left untouched. This alteration was apparently for the curious reason, according to Brown, that 'we ought not to go up and downstairs in the open air'.

Brown's inhibitions did not extend to the formal gardens in Richmond Old Park and he soon replaced the formal pool and straight walks with his own style. He dispensed with Merlin's Cave Grotto, a weird construction put up by William Kent for Queen Caroline. This thatched building had contained six life-sized wax figures and had proved the subject of much contemporary satire. The landscaping on

Left: The Great Vine at Hampton Court was planted, as a cutting, by Brown in 1768. Now 78 inches in girth, the vine still bears fruit.

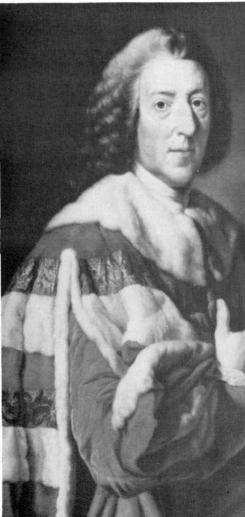

Right: William Pitt, first Earl of Chatham (1708-1778), leading Whig politician. Brown accepted a commission from Pitt, and the two men became friends.

which Brown worked now forms an area of Kew Gardens and includes the 'hollow walk', now known as the rhododendron dell.

ENGAGING ASSISTANTS

Brown was exceedingly occupied in what he himself described as 'galloping about'. Sometimes, as he wrote, his employees, during his absence, were busy too — making 'blunders and neglects'. About 1765, probably to avoid such lapses, he took on two helpers, Samuel Lapidge and Michael Millikin. Lapidge, born in 1744, undertook routine survey work and seems to have travelled round with Brown. His name appears in Capability's account book.

Millikin, a young Scottish gardener, had come to Brown's notice while working at Chatsworth for the Duke of Devonshire. He now became Brown's personal assistant, a trustworthy foreman who could satisfactorily be left in charge at Hampton Court in the absence of his master. His was a crown appointment at a secretly fixed salary, which he considered very generous, of £150 per year. He first lodged at the Coach and Horses on Kew Green and later, when joined by his wife, lived in a house at Kew. He dealt with the stream of callers, from nurserymen, blacksmiths and gardeners soliciting orders and employment, to the King himself, sometimes with the Queen and the royal children. Indeed the royal family might visit two or three times a week. It was necessary to urge discretion upon his young wife in the matter of conversations between the King and Capability which came to the ears of Millikin.

Millikin served the king for thirty-five years and on his death his wife was given permission to remain in the family home.

AN IMPORTANT FRIEND

Brown was now receiving commissions from many important Whigs as well as from the great Catholic families. In 1765 he accepted a job from the greatest Whig of all, the 'Great Commoner', William Pitt, soon to become Earl of Chatham. No doubt he had met Pitt at Stowe; he knew him to be interested in landscape gardening and knowledgeable about it. Pitt required a memorial pillar for the estate of Burton Pynsent, to commemorate his political admirer, Sir William Pynsent, who had bequeathed the estate to Pitt. The classical vase surmounting a pillar produced by Brown proved satisfactory to Pitt, who recommended the designer to Grizel, wife of Earl Stanhope.

In an interesting and much-quoted letter to this lady, Pitt epitomised Capability's unique social position:
'The chapter of my friend's dignity must not be omitted. He writes Lancelot Brown Esquire, en titre d'office; please to consider he shares the private ear of the King, dines familiarly with his neighbour of Syon and sits down at the tables of all the House of Lords and c. To be serious, Madam, he is deserving of the regard shown to him, for I know him, upon a very long acquaintance, to be an honest man and of sentiments much above his birth.

There is perhaps a gentle amusement at Brown's rapid social elevation but no outright criticism. Dignified respectfulness was probably Brown's likely attitude. His portrait by Nathaniel Dance seems to indicate a shrewd personality, dressed in sober garments, with sharp observant eyes under thick brows and a firm, humorous mouth. In any event, a relationship well beyond that of employer and employee grew up between Brown and the Chathams. The two men were friendly, with Lady Chatham usually acting as scribe to Brown for herself and her husband.

The Chatham papers give many hints of a friendship which lasted for forty years. On Brown's side there are many enquiries as to the state of Chatham's health, admiration for his integrity and solicitude regarding the Earl's political position; this in a time when, as Lady Chatham pointedly wrote, there were 'restless and intriguing spirits' about. Lady Chatham lightly discussed family affairs and bewailed the gout which 'broke in on their amusement'. Lancelot, in his turn, did his utmost to secure a suitable town house for his friends and to commend the Earl to his royal patron, George III, on all possible occasions.

A PLACE OF HIS OWN
Brown had settled happily into Wilderness House. His fifth child, Margaret, was born between 1752 and 1760, and Thomas, his last child, in 1761. Also in 1761 Lancelot Junior was sent to Eton. Brown wished for a country property of his own. This he at last acquired, after some disappointments, through a client, the eighth Earl of Northampton. In 1761 Brown had begun professional work upon the estate at Castle Ashby for the previous Earl and had continued improvements when the eighth Earl succeeded. Some years of labour produced a transformation on a grand scale at Castle Ashby, Brown

creating a new landscape park and removing three of the four old avenues which extended from the house. The best of the ancient trees were preserved, some of which are thought still to flourish.

Brown's account book gives interesting details of the work carried out for the Earl 'during his absence from England'. This included 'making a sunken fence and a wall between the red deer paddock and the kitchen garden, by His Lordship's order' and 'pulling down the old ice house and building a new one in a very expensive manner and place'. This last activity involved much effort and we find disbursements made immediately for 'carting fresh mould' and 'keeping the newmade ground'. There is also a mention of a 'great general plan for Castle Ashby'. Later on a Mr Hobcraft was paid £4.40 for 'going twice to Castle Ashby to see about the dairy'.

Lord Northampton possessed a property, the Manor of Fenstanton, in Huntingdonshire, which he contemplated selling and to which Brown was much attracted. This house was offered to another interested party, refused, then withdrawn from the market. Eventually, needing some ready cash for heavy electioneering expenses, the Earl agreed to sell the property to Capability. The correspondence between

Fenstanton Manor, probably the manor-house which Brown bought from the Earl of Northampton as his own country estate in 1767.

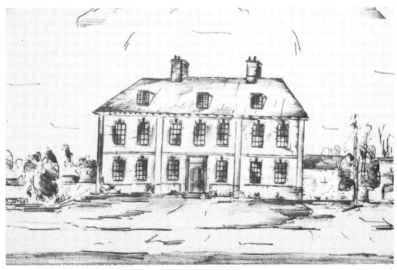

Brown and Lord Northampton gives 8th June 1767 as the 'happy day' on which Brown learned the good news.

Today at Fenstanton there are two manors, the larger of which has, on its outer wall, a Sun Insurance firemark and, according to insurance company records, a policy was taken out by Lancelot Brown of Hampton on 13th October 1773. However, as the owner of this manor points out, an article about Capability Brown in a magazine has shown, accompanying the text, one picture of the staircase of the above-mentioned house, plus also a picture of the outside of the second manor-house, so there is not unanimity as to the identity of Brown's residence.

However, Brown certainly moved to Huntingdon and when time permitted, lived the life of a country gentleman. He was ten miles only from the Cambridge colleges and made friends with at least one academic, the theologian Professor John Mainwaring, apparently a fellow-sufferer from asthma and a keen amateur gardener.

A HOUSE FOR ROBERT CLIVE

Towards the end of the 1760s, the flamboyant Robert Clive, 'conqueror of India', returned to England as an immensely wealthy man. He purchased a town house in Berkeley Square and also three country seats, adding these to the family home which he had already inherited. His choice for one of these country estates fell upon Claremont, in Esher, Surrey, which he bought from the widow of the Duke of Newcastle in 1768. He decided that he did not care for its appearance — it had been built by Vanbrugh — and that he would prefer a plainer and currently more fashionable style. Moreover the site was low-lying and damp. Accordingly he sought suggestions for designs from both Capability Brown and also from Sir William Chambers, a professional rival of Brown's who had carried out other work for Clive. Brown was successful with his design, a fact which Chambers took hardly.

Brown was responsible for both the house and grounds at Claremont and this commission was very profitable. The dignified Palladian building, on a new and higher site, which Brown designed and which still stands, now a school, bore good views over the surrounding Surrey countryside. A certain number of bricks and slates from the old house were used but about a million and a half new bricks were needed; these were made on the spot, in the park.

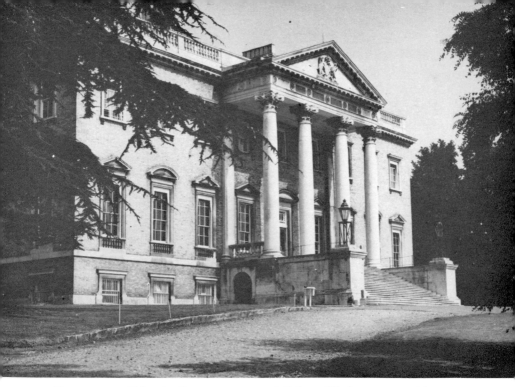

Claremont, at Esher in Surrey, was one of Robert Clive's country estates.
Above: a modern photograph of the house, now a school, designed by Brown in
the Palladian style. Below: an engraving of the park laid out by Brown.

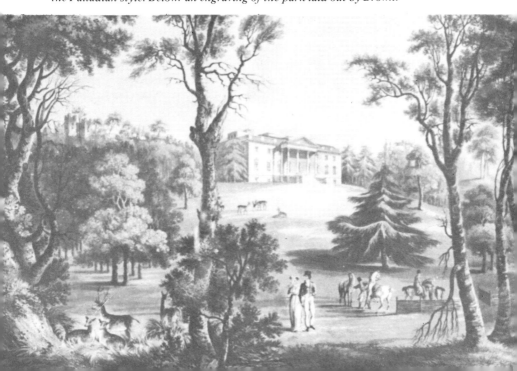

The building work was again carried out by Brown's friend and colleague, Henry Holland. Costs were seemingly limitless. The columns of the great portico bore Corinthian capitals and the friezes were ornamented with six lions' heads. In the grounds, Brown concentrated on extensions rather than alterations, retaining the ground round the belvedere, or turret, which section was probably laid out by his old master, William Kent. Brown is credited with the planting of splendid cedars to frame the new house. Somewhat unusually, the building had four facades, with an unbroken sweep of sward round the house, and the kitchen and outbuildings at a little distance, connected by a concealed tunnel.

Rumours filled the Surrey air concerning Clive and his activities. According to the essayist Macaulay, it was 'whispered that the great wicked Lord had ordered the walls to be made so thick in order to keep out the devil'. It is not known for certain whether Clive actually lived at Claremont; if he did, it was for a period of only about a year. He died, ill and vilified, before Claremont was completed.

AN HONOUR FOR CAPABILITY

In 1770 Capability was made High Sheriff of Huntingdonshire. The selection of a suitable person for this appointment was made from among likely landowners, from a list of three names suggested by the Chancellor of the Exchequer and the Judges of the King's Bench Division. The King made the appointment and no doubt when George III saw his friend's name among the nominations there was a certainty as to whom he would choose. Some saw the appointment, a little unkindly, as an official recognition of Brown's having become a 'gentleman'. He was certainly an artist of genius and a thoroughgoing businessman.

The relentless years

AN UNPLEASANT INCIDENT

In 1772 a minor bombshell burst upon Capability. It came in the form of a printed criticism of his style of garden design, appearing in a book called *A Dissertation on Oriental Gardening*, and was produced by his rival in the affair of the Claremont plans, Sir William Chambers. Ostensibly a treatise of a general nature on oriental gardening, it was seen by contemporaries as a pointed and unpleasant personal attack upon Lancelot Brown. To be accused of 'want of judgement and poverty of imagination' was disagreeable; to have it stressed that *Chinese* gardeners are neither 'ignorant nor illiterate' was hurtful; to be designated 'a cabbage planter' and arraigned for 'sweeping away thousands of venerable plants' in a 'humour for devastation' to 'make room for a little grass and a few American weeds' was unjust.

William Chambers was a person of unassailable position, H.M. Comptroller General and Treasurer of the Royal Academy, an able architect, designer of London's Somerset House. In disliking Capability's picturesque landscapes he was not without sympathisers. Basically he advocated a richer plant material in garden-making and the addition of follies and 'chinoiserie' such as the Chinese pagoda still standing in Kew Gardens. Probably Chambers never visited China or saw a genuine Chinese garden. It is likely that his predilection for things Chinese had two sources, a Jesuit pamphlet upon the Imperial Pekin gardens, and a knowledge of Chinese architecture acquired from some other French source — social contacts between the French and the Chinese being well established.

Chambers was a fine architect but in his *Dissertation* he laid himself open to ridicule and showed ignorance of the basic horticultural knowledge with which Brown was so well equipped. It may well be that the affair of the Claremont designs was for Chambers the 'last straw' and henceforth a turmoil of emotion overcame reason.

Any public figure has detractors and Capability was no exception. There were probably three counts on which he was exposed to comment. These were his association with the great Whigs, his modest social origin and his role as an innovator. Brown's rapid rise to fame and position and the exalted station of his patrons made him particularly vulnerable to gossip. It is to his credit that he appears to have expressed no public reaction to the outburst, but continued working at Claremont, maintaining a dignified silence.

A contemporary satirist, William Mason, immediately produced a sarcastic riposte in Brown's defence, but Brown himself quietly rode out the small storm. He was too busy and successful now to be affected by a rival.

FAMILY AFFAIRS

Brown seems to have enjoyed a contented family life. His business and friendly relations with the Henry Hollands, whom he had first met in Hammersmith, persisted through the years. Lancelot had noted with interest the development of his friend's son, young Henry Holland, who possessed not only social gifts but also unusual architectural talent. Lancelot accepted philosophically that none of his three sons was likely to join him in his profession. The eldest, young Lancelot, known since his Eton schooldays as 'Capey', was looking to politics for his future. Resignedly, Brown realised that if he wanted a colleague in his business enterprises and reliable help on the architectural side, he could do no better than turn to Henry Holland the younger.

Perhaps with a view to maintaining happy relations, rather than exposing them to strain, Brown did not take young Holland into his own practice as partner, but exerted influence and energies to set the young man up in his own practice in London's Mayfair. Brown ensured that young Holland obtained good commissions — the young man worked on the interior decoration on the Claremont property — and introduced him to some of his own wealthy clients.

The Brown family in its entirety seems to have felt affection for young Holland; the relationship deepened, particularly between the young people of the two families, who had grown up together. About a year after young Henry had set up on his own, he proposed to Capability's daughter Bridget and the following year they were married. The wedded couple, with their excellent prospects, went to

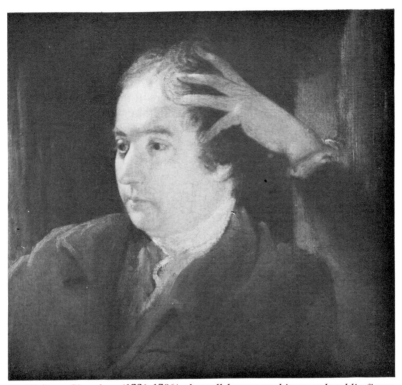

Sir William Chambers (1726-1796), the well-known architect and public figure, and a professional rival and critic of Brown.

live in London in Half Moon Street. Later, young Henry built his own house in Hertford Street.

In the middle 1770s Lancelot Junior decided to crystallise his political ambitions and sought a parliamentary seat. The home administration, under Lord North's premiership, was short-sighted, with George III totally absorbed in international politics and party intrigue rife. In April 1775 the American War of Independence began, to drag on for the next seven years.

Capability naturally wanted to help his son. Parliamentary elections were then doubtful affairs, where a young hopeful needed either to be wealthy or to get himself 'adopted' by a landed magnate with seats in his personal control. Few boroughs were open to free and fair election. Capability, somewhat naively, approached James Lowther, later Earl

35

of Lonsdale, as a sponsor, Known as 'the bad earl', Lowther controlled nine seats, whose occupiers were called 'Lonsdale's ninepins'. Lowther was an unstable person altogether and owed Capability a good deal of money. Lowther did invite Capey to his home, make him vague promises and involve him in electioneering chores, with the seat of Cockermouth dangled before him. A similar treatment was accorded to a youthful kinsman of Lowther's, Walter Spencer Stanhope. Both young men were bewildered at Lowther's machinations. In the event nothing came of this interlude. Capey had to endure a further wait.

A COLLEGE GARDEN

During the middle and late 1770s commissions continued to pour in for Capability. Despite political unrest people still felt it prudent to 'improve' properties. Probably through his friendship with the Cambridge professor John Mainwaring, Brown agreed to carry out some work in the Fellows' Garden, or Wilderness, at St John's College. A college order dated July 1772 reads: 'agreed that the bank be repaired under the direction of Mr Brown'; but it is generally thought that Brown removed the old bowling green and adjacent formal gardens and replaced these with lawns and trees. Since he had been called in by friends, the delicate question of remuneration was solved as indicated in a college order dated 26th March 1778: 'agreed that a piece of plate of the value of £50 be presented to Mr Brown for his services in improving the walks'.

Lancelot would have liked to work much more freely on the Cambridge backs and, for sheer pleasure, prepared and presented a grand plan for their redesign. He visualised an even more delightful 'picture' by treating the area as a unity, instead of a series of miscellaneous garden areas. College boundaries would be ignored in his plan, King's would be substituted for the 'great house' and, not surprisingly, the river Cam diverted. However, this plan was not acceptable to the University authorities and a payment of £50 for the preparation of the plans was the sole outcome of Brown's splendid vision.

JOURNEYS, JOURNEYS

Among his undertakings in the early 1770s Brown executed a mainly architectural commission, in collaboration with Henry Holland, at Benham, Speen, in Berkshire, for Lord Craven. Here he built an

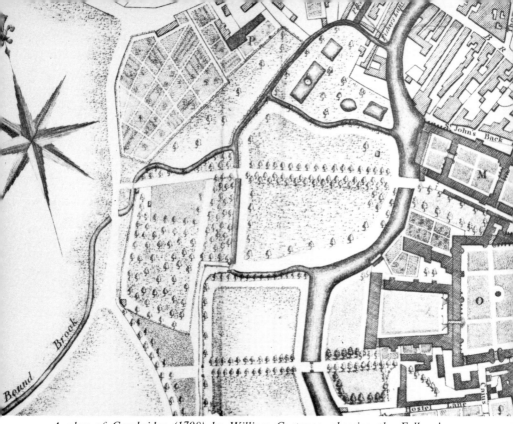

A plan of Cambridge (1798) by William Custance, showing the Fellows' Garden, St John's College (the tree-covered area on the left), after Brown had worked on it.

elegant three-storey mansion with a vast portico. At Bowood, near Corsham in Wiltshire, the grounds alone concerned Brown and here he supervised a strenuous programme of river-digging and lake-building, enclosing part of the grounds by sunken fences and making rides. He also had planted many common trees and shrubs, including twelve thousand hawthorns, as well as more exotic trees. The parkland at Bowood remains today much as Brown left it.

Brown and Henry Holland worked harmoniously together. They tried to persuade clients to use their ideas, but occasionally they had to compromise.

At Syon House near Kew Brown designed for his old friend and patron the Duke of Northumberland, an insatiable improver. He swept away the old garden and planted all obtainable foreign trees and shrubs. Unlike the vast spaces of Alnwick, the Duke's northern seat,

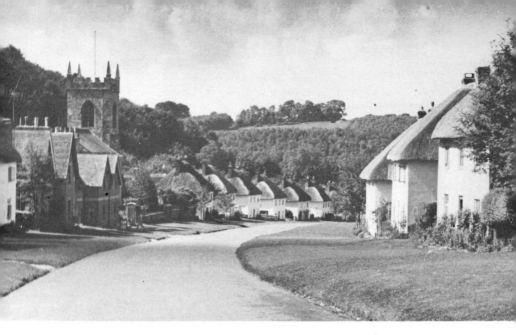

Milton Abbas, Dorset, a village of thatched cottages ordered by Lord Dorchester to replace the previous village demolished in a grand 'improvement' scheme. Brown was probably responsible for the village.

Syon was not extensive but Brown contrived an effective design, removing walls and opening up the delightful view.

Harewood, in Yorkshire, became known as another of Brown's masterpieces. The owners of Harewood, the Lascelles family, had become wealthy in the Indies and the Adam brothers had erected a fine house with delightful views to replace the original old manor of Gawthorpe. Liberal funds were also available to transform the grounds and Brown dammed streams and flooded the valley, forming a great lake and placing many new plantations. This elaborate commission spanned ten years.

Another use of a fine natural setting — in this case overlooking the Solent — was the landscaping at Cadlands, Hampshire, for a wealthy Scottish immigrant, the Hon. Robert Drummond. The great house on this property was worked on by Henry Holland.

At Clandon Park Brown replaced an old French garden and transformed a canal into a lake. He landscaped Edgbaston Park, which is now, like at least four other Brown landscapes, the basis for a splendid golf course. (The others are Wimbledon, Addington, Moor

Park and Ashridge.) At Caversham he thinned the trees vigorously to give them a better chance to develop. Wags commented here that it was 'impossible to see the trees for the wood'; it was this apparent ruthlessness that gave rise to criticism from time to time by those who did not properly grasp Brown's ideas.

This same ruthlessness caused upheaval at Milton Abbey, where Brown's detractor, William Chambers, had built a fine new house surrounded by grounds on which Brown had previously worked. The owner, Lord Dorchester, had decided that for aesthetic reasons the entire village of Milton Abbas must be re-erected. Demolition and rebuilding took place and it is probable that the new village was designed and built by Brown since he received £105 for plans for the village and, as his account book states, made continuous journeys to Milton between 1773 and 1776. The new village consisted of pairs of thatched cottages with neat gardens on either side of a wide road, with chestnut trees between the cottages. This arbitrary method of re-aligning the tenantry was not confined to Lord Dorchester but was practised by other landowners. A Perpendicular church and alms-houses were also built.

Brown was increasingly troubled with asthma. He was still very much in command, despite increasing years, and still wrought miracles of reconstruction with his 'improvements'. He took some part in the landscaping of Cliveden, which possessed wonderful views over the river Thames, and engaged in several years of gruelling work to make a picturesque garden of the 350-acre estate at Chilham Castle in Kent. The house, built on a steep bank, had been designed by Inigo Jones (1573-1652) who had introduced the Palladian architectural style into England and had held the appointment of Surveyor of the King's Works. Chilham had an Italianate garden and this commission presented a large canvas. Planting was the largest task here and a lake was formed in the valley. The seventeenth-century yew terraces and the old Judas tree were retained. Much of this work survives and the delightful prospect across the lake remains, along with some fine trees.

Brown also accepted the challenge of Nuneham Courtenay, owned by Lord Harcourt, which was described by Horace Walpole as 'rough as a bear but capable of being made a most agreeable scene'. Brown's plans for the house and grounds were accepted and Henry Holland built two new wings linked by a curved corridor. 'Taming the bear' called for much thinning of woods and new planting and the pleasing

result elicited a poetic tribute from the Laureate of the day. Here again the designer made the utmost of the naturally beautiful setting, this time a reach of the Thames.

Towards the end of the 1770s Chatham died and Brown felt the loss deeply. Lancelot had greatly admired Chatham. According to an apocryphal anecdote, the Earl had at one time adjured Brown, 'Go you and adorn England,' to which Brown is supposed to have replied: 'Go you and preserve it.'

Brown had the satisfaction of seeing his eldest son, Capey, returned at last to Parliament as member for Totnes in Devon, an achievement in which Capability had no part. Capey was hardly born for greatness; he was never more than a 'patron's member' and made little mark on the political scene. Years later, when fighting a further election, a scurrilous bill compiled by a political enemy described him as a 'meer mushroom sprung from a dung-hill in Stowe gardens'. This robust taunt reminded him of his humble ancestry and his own inadequacy. However, he obtained a seat and eventually received the appointment of Gentleman of H.M. Most Honourable Privy Chamber.

NEW DECADE

Capability entered the 1780s with a full schedule. He was still riding up and down the intolerable roads on his 'journeys'. On these thoroughfares coaches frequently got bogged down, overturned or lost wheels or axles. Apparently circuit judges refused to travel at that time to Lewes because of the terrible roads. No roads went beyond Exeter in Devon that were then fit enough for carriages or coaches. As one travelled, irritating tolls had constantly to be paid and robbery and violence beset travellers, with law officers thin on the ground. Notwithstanding such annoyances, Capability, now well beyond middle age, still pursued his profession, though his hardworking draftsman assistant, John Spyers, carried out much of the preliminary surveying.

Not all clients were a delight to deal with and Brown prepared plans, which came to nothing, for Lord Bristol, who had already proved a tiresome nuisance to a series of architects. But Capability, whatever his feelings, was unfailingly polite, as witnessed by another client of the early 1780s, Mrs Elizabeth Montague, who said of Brown: 'He really gives the poor widow and her paltry plans as great attention as he would bestow on an unlimited commission ...' Mrs Montague

herself was a very rich widow, known as the Queen of the Bluestockings, and a great party-giver. She coveted improvements to her house at Sandleford Priory. Capability did not see the completion of this undertaking, but it was finished under the direction of his assistant, Samuel Lapidge.

THE LAST 'JOURNEYS'

Brown went on further journeys to Suffolk, to landscape grounds at Heveningham Hall for Sir Gerard Vanneck. A splendid new mansion had just been completed. Brown drew up two sets of plans, one for the area immediately around the house and another for the remaining grounds. In the more extensive area he was thwarted by the grumbles of neighbouring landowners in his wish to make a river run parallel with the main carriage drive. Eventually he created a narrow, irregular lake, filled by springs discovered in the grounds, and spanned this by an isthmus of trees instead of the more conventional bridge. He also gave much thought at this time to properties at Ickworth and Farnham.

The summer of 1782 was very wet; this made travelling difficult and earth-moving operations awkward, slowing down the completion of contracts. Capability felt tired and unwell but had stubbornly accepted commissions and assignments, some of them entirely new. He committed himself to work in Yorkshire, at Byrom and Stourton, though John Spyers was making preliminary surveys. Brown also agreed to journey in Gloucestershire and Wales. It seemed as though a daemon drove him on, when he could have retired comfortably to the peace and quiet of Fenstanton. Disposed about the manor-house were the signs of his success and acquired tastes, mentioned in the will he had drawn up a few years earlier. He could have lived happily among the books, plate, china, linen, valuable snuff-boxes, prints, pictures and silver candlesticks, as well as the jewels, rings and watches which the former garden boy had accumulated throughout the years. And to visit friends, or ride for pleasure, there was the 'chariot' or coach, with its fine horses, or a saddle horse if preferred.

However, Capability had no intention of retiring. He was heartened by the mild winter which succeeded the summer rain. In December 1782 he went once again to stay at Wilderness House. It was a brief visit before setting off once more for Suffolk. He found it delightful to stroll, even at that time of year, in the gardens of Hampton Court. He

41

came across Hannah More, a famous intellectual of the day, and was well enough to engage in conversation with that lively lady. They chatted about his profession. In a moment of inspiration Capability likened the garden which he designed to the elements of a literary composition: there was the comma, the colon and even parenthesis. Finally, he declared, there was 'a full stop and then I begin another subject'.

After the brief Suffolk visit, he returned to London in February of the new year, 1783, to stay with his son-in-law and daughter Bridget, the latter still loved 'with unchangeable affection', at their home in Hertford Street. On 6th February he decided to go and call on his old friend and patron Lord Coventry at the latter's London house in Piccadilly. He had been on good terms with Lord Coventry since his own plunge into architecture thirty years earlier, when Coventry had inexplicably placed his trust in the unknown Brown — unknown, that is, in the realm of architectural design.

Having returned to Hertford Street, Brown reached his daughter's front door when he was gripped by severe pain; he had suffered a heart attack. He staggered, fell to the ground and shortly afterwards, having been taken into the house, he died. The 'journeys' were ended. The final entry had been made in his account book. It records work in Stourton in Yorkshire and monies are credited as 'received by S. Lapidge and accounted for to the executors'.

AN ASSESSMENT

Horace Walpole dubbed him 'Lady Nature's second husband'. The sophisticated Walpole affected some public flippancy as to Brown's qualities but included among his private papers a eulogistic printed obituary notice of the deceased. It was a long time since Walpole had written, somewhat patronisingly, on seeing the 'improvements' at Warwick Castle that the grounds there had been 'well laid out by one Brown, who has set up on a few ideas of Kent and Southcote . . .'

Opinions seem to have been unanimous as to the character of Brown. No one denied him the virtues of his tomb inscription at Fenstanton — 'Christian, husband, father and friend'. His son-in-law and business associate, Henry Holland, who had more opportunity than most to know the real man, paid him tribute. As an architect, according to Holland, no one had equalled Brown when it came to 'setting his buildings on a good level', 'designing good rooms', or

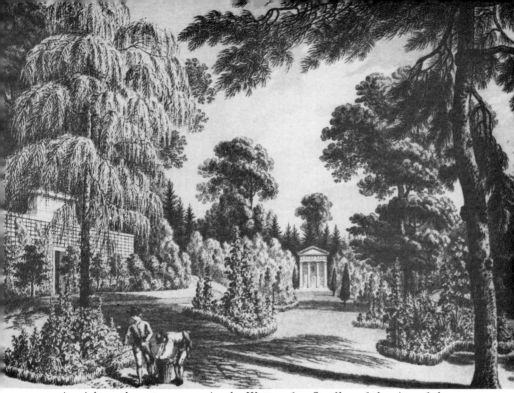

An eighteenth-century engraving by Watts, after Sandby, of the view of the flower garden at Nuneham Courtenay, Oxfordshire, laid out by Brown.

'providing for the approach, drainage, comfort and convenience of every part he was concerned with'.

There seems no reason to doubt that Brown enjoyed a felicitous family life, happy among his wife and children and concerned for their welfare. His wife Bridget, described in his will as 'dear, faithful and affectionate', and their children, Lancelot Junior, young Bridget Holland, Margaret, Thomas and John, were all provided for.

There can also be no doubt about Brown's prolific activity. He is thought to have 'improved' to a lesser or greater degree between 120 and 140 great country estates, the most important of which are described in this book. He was tireless and disciplined in accepting commissions.

BROWN AS LANDSCAPER

With regard to his garden designing, he was not without critics. He aspired to a gentle serenity but some accused him of lack of visual excitement, also of working rigidly to formula. He was denigrated for the 'destruction' of established beauty. No doubt he sometimes suf-

fered an excess of zeal, as when at Blenheim he blotted out that unique pleasure garden, the Great Parterre. He was accused of 'wholesale' tree-felling. It was said, too, that his plantations when new looked stiff and bare and his river banks 'naked'. It is true that he was ruthless in removing obstructions to what he considered a superior prospect, but always with a definite object. He cannot be faulted as a tree-lover; it is believed that he planted over a million trees. He had confidence in the future and planted for posterity. The wooded glades provided timber to pay for death duties in succeeding generations. Brown did not wish watersides to be concealed but in time rushes did soften the outlines. A further, more sociological, objection to Brown's designs castigated the islanding of the house in an ocean of lawns, as cutting off the residents from the 'ordinary people'. This is hardly credible considering Brown's own easy disregard of social barriers.

The cumulative effect of his work was to create within the English countryside superb natural landscapes and well-planned houses, arousing envy and imitation at home and overseas. The American, Thomas Jefferson, after visiting England and viewing Blenheim and Stowe, decided to landscape his estate, Monticello, in the style of the English parks.

GLIMPSES OF THE 'IMPROVEMENTS'

As to what has remained of Brown's work, the British nation of garden lovers, farmers and industrialists, with their alterations, digging and building, inevitably destroyed most of Brown's creations. Comparatively little remains to delight us. Yet from time to time we can experience the pleasure of discovering one of Capability's achievements and beholding a certain matchless view or architectural feature much as he left it. You may, for instance, see the undulating lawns at Audley End, Saffron Walden, or the house at Berrington, Leominster, with the wide semicircular view from the front steps; or the lawns, lake and house-flanking cedars at Danson Park, Bexley. You may confront certain fine trees at Castle Ashby or the incomparable lake at Blenheim; you may see the ice house at Heveningham Hall or the rhododendron dell at Kew, or the picture gallery with its elaborate ceiling at Corsham Court. There is a vestige of Brown's work on the Addington, Kent, golf course and in the fine view of Longleat, from the Warminster road, showing how Brown could see in his mind's eye the 'picturesque capability' of each

44

property. These are a few reminders scattered throughout the countryside of the immense energy and accomplishment of Lancelot 'Capability' Brown, former garden-boy who died, rich and respected, in 1783. Through the acquisitions of the National Trust and the willingness of private landowners, we may catch some glimpses of those 'improvements' which it was Brown's business and pleasure to create.

Brown's ideas were modified by his immediate successor, Humphry Repton, and after a while temporarily forgotten. Over the last twenty years a new and rewarding interest has been aroused. Capability is well summed up in the words of an anonymous writer, words published about 1767 by the ubiquitous Horace Walpole:

'Born to grace Nature and her works complete
With all that's beautiful, sublime and great!
For him each muse enwreathes the laurel crown
And consecrates to fame immortal Brown'.

Harewood House, Yorkshire, where the park is one of Brown's masterpieces. This commission was from the Lascelles family who had gained a fortune in the Indies.

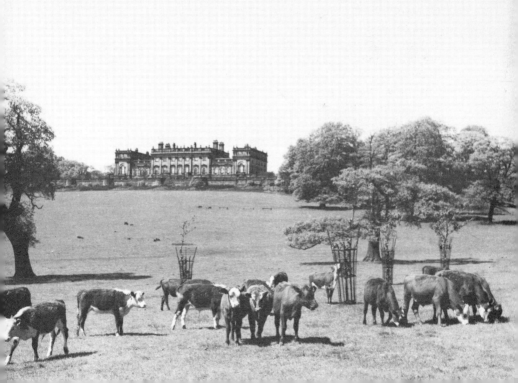

THE PRINCIPAL EVENTS OF BROWN'S LIFE

1716	Lancelot Brown born at Kirkharle, Northumberland
1727	*George II succeeded to the throne*
1732	Brown apprenticed to Sir William Loraine
1739	Moved south to Wotton: Sir Richard Grenville
1740	To Stowe Park: Lord Cobham
1744	Brown married Bridget Wayet of Stowe
1745	*The Young Pretender's rebellion*
1749	Brown set up on his own in London. Met Henry Holland
1760	*George III succeeded to throne*
1760	Brown began work on Blenheim Palace
1764	Royal appointment as H.M. Surveyor of Gardens and Waters. Official residence at Hampton Court
1765	Worked on pillar for Earl of Chatham: important friendship
1767	Purchased Manor of Fenstanton for himself
1769	Worked at Claremont for Robert Clive: conflict with William Chambers
1770	Appointed High Sheriff of Huntingdon
1772	Chambers's *Dissertation*
1772	Brown set up Henry Holland Junior in business
1773	Holland Junior married young Bridget Brown
1774	Attempt to obtain parliamentary seat for his son Lancelot Brown
1775	*Beginning of War of American Independence*
1777	Work at Cardiff Castle
1777	Attempt to intervene with George III on behalf of Chatham
1780	Brown tired, unwell, still travelling relentlessly
1782	*End of War of American Independence*
1783	Death of Lancelot 'Capability' Brown

BIBLIOGRAPHY

Gapper. *Blue Guide to the Gardens of England*. A. and C. Black, 1991.

Hyams, Edward. *Capability Brown and Humphrey Repton*. Dent, 1971. Has useful appendix of surviving works of Brown arranged in counties.

Jellicoe. *The Use of Water in Landscape Architecture*. A. and C. Black, 1971. An aspect of garden design in which Brown was particularly interested.

Law, Ernest. *The History of Hampton Court Palace* (Volume III). 1891.

Stroud, Dorothy. *Capability Brown*. Country Life, 1950. Detailed, giving authoritative verification of sites and features.

Thacker, Christopher. *The History of Gardens*. Croom Helm, 1979.

Exploring Britain's Great Gardens. Readers Digest Association, 1984.

Official guide-books, among them: Berrington Hall, Leominster (National Trust); Wallington, Northumberland (National Trust); Stowe; Blenheim Palace; Hampton Court Palace.

The personal account book of Capability Brown. The property of Mrs Morrice of Colchester but in the care of the Royal Horticultural Society.

INDEX